colorblind
photography

Being colorblind gives an advantage when composing black & white photography... less confusion.

This special collection selected from thousands of captures. All images were framed in the camera and presented without edits, genuine as seen through the lens with unique process.

Original fine art and custom work available.

info@ BEACHNOISE.com

Joseph Fleming

JH FLEMING
© 2015 ALL RIGHTS RESERVED

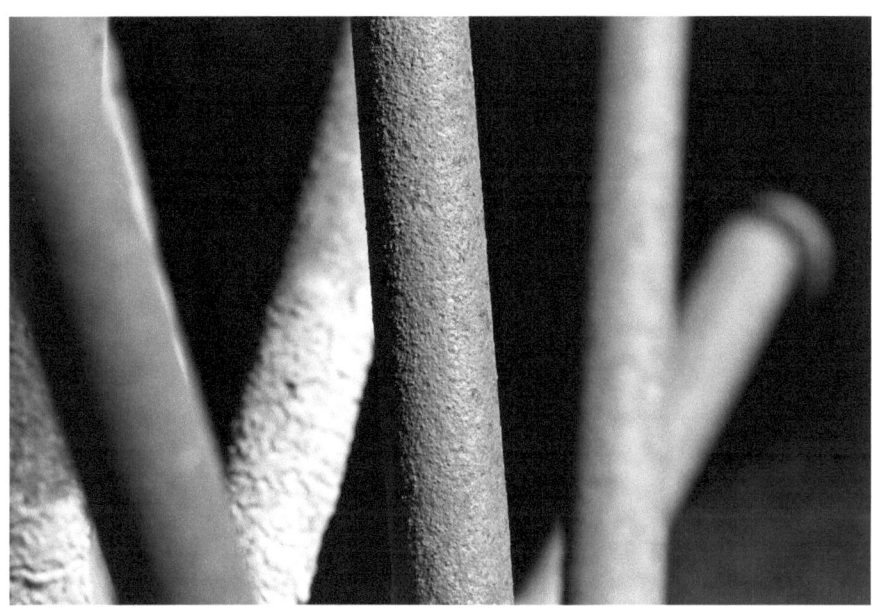

0780

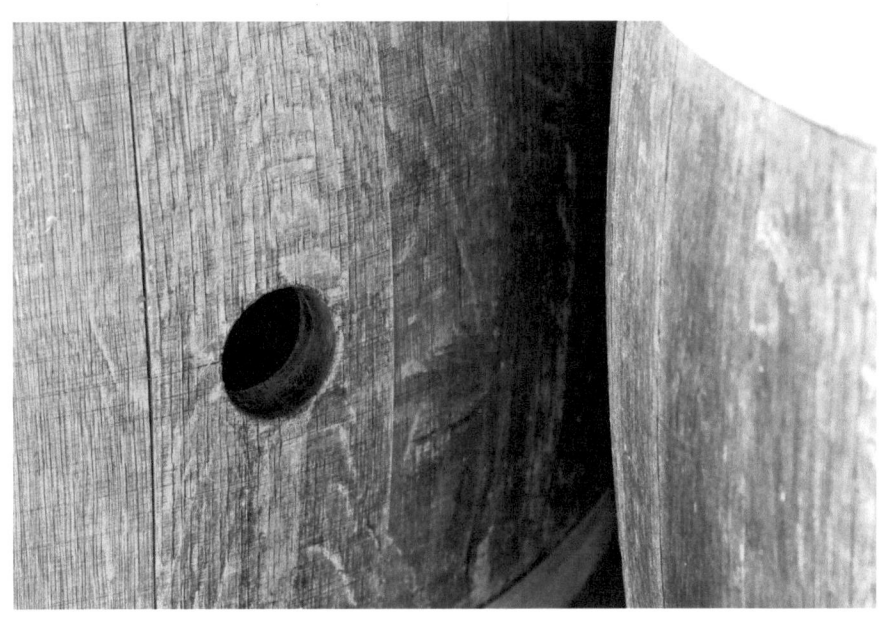

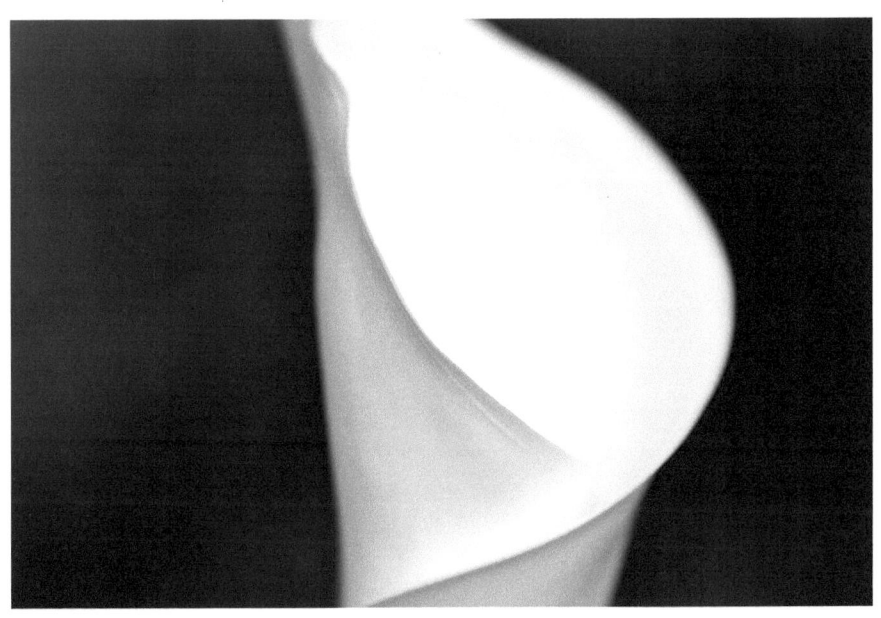

0920

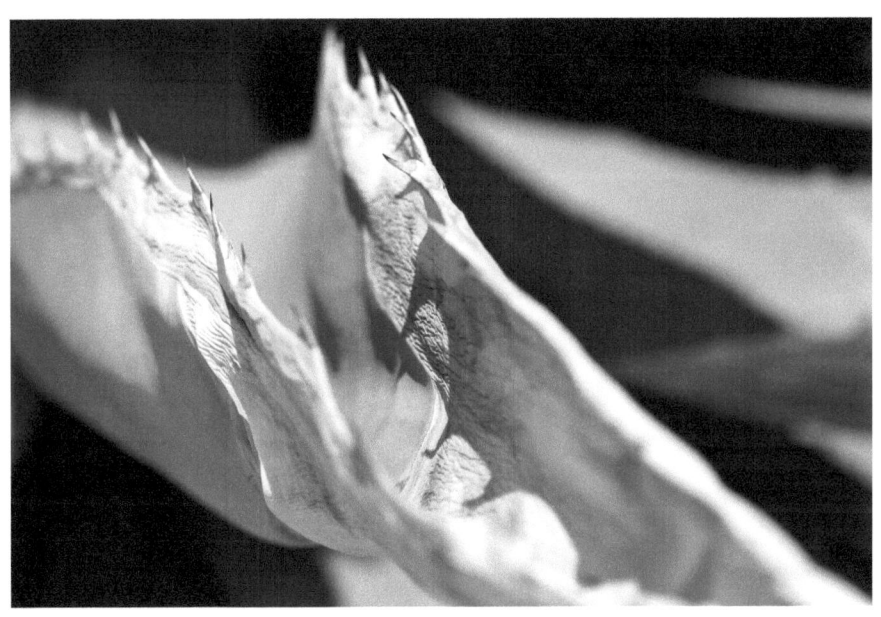

1581

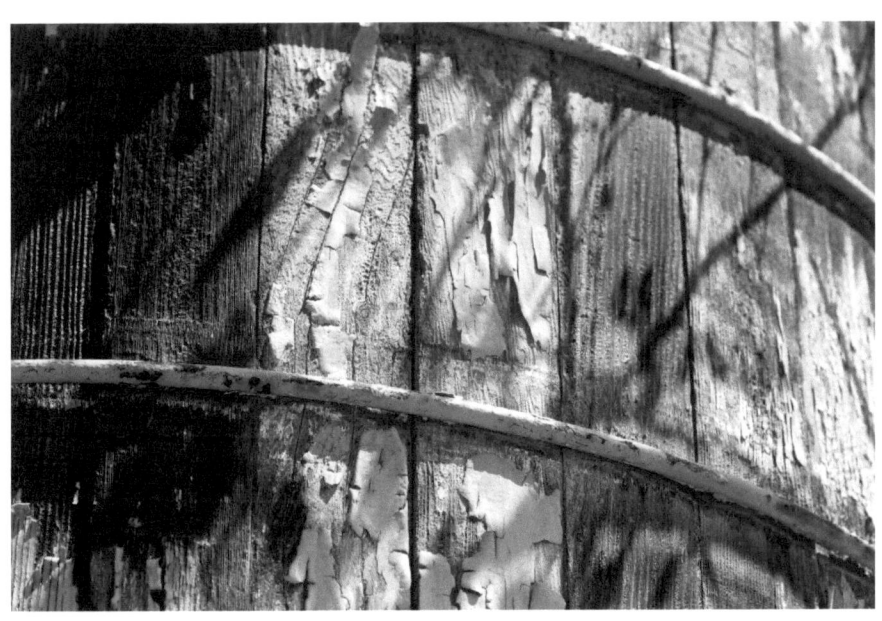
1608

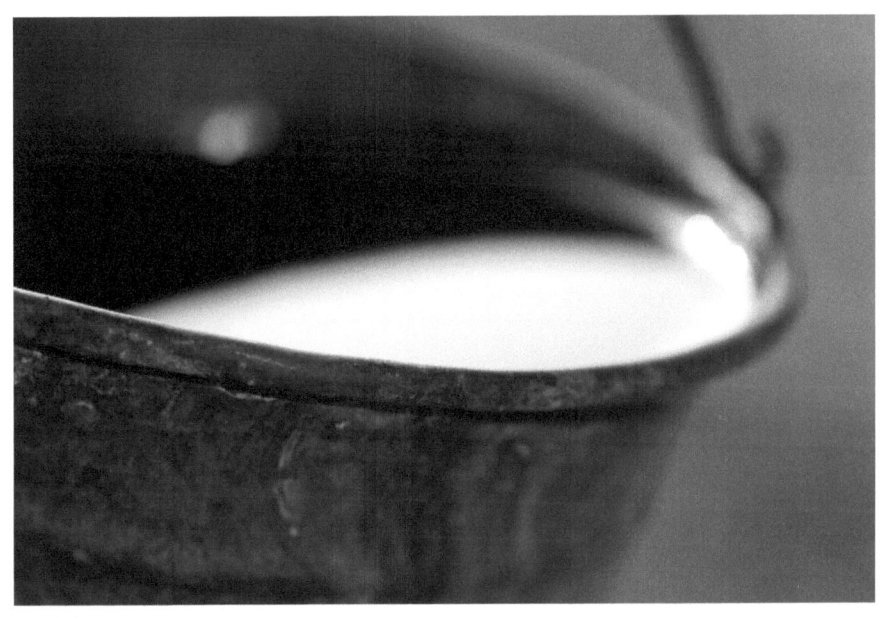

2180

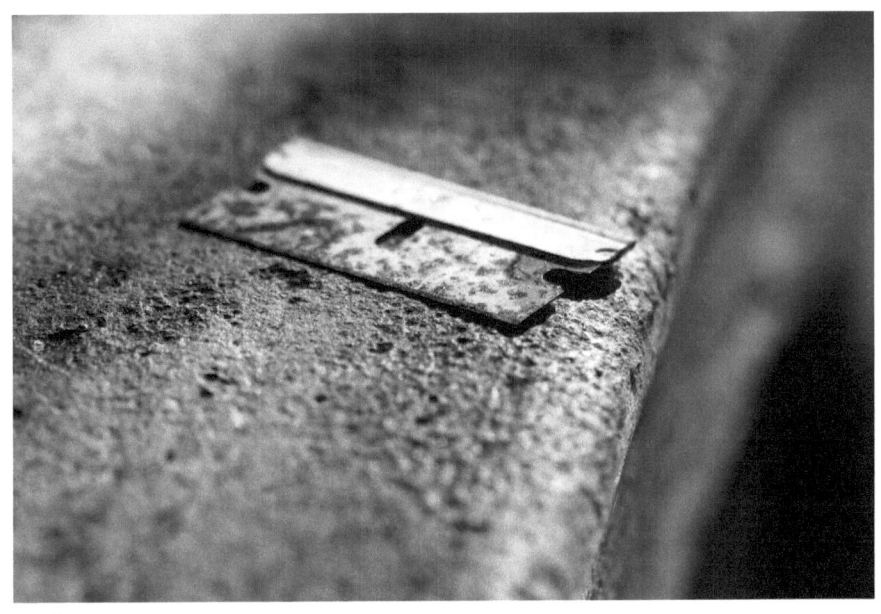

2467

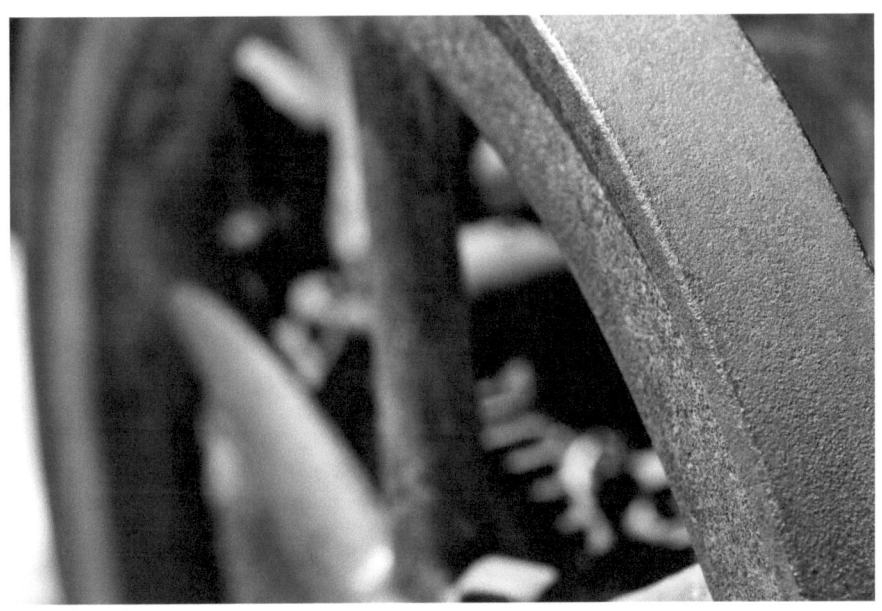

2962

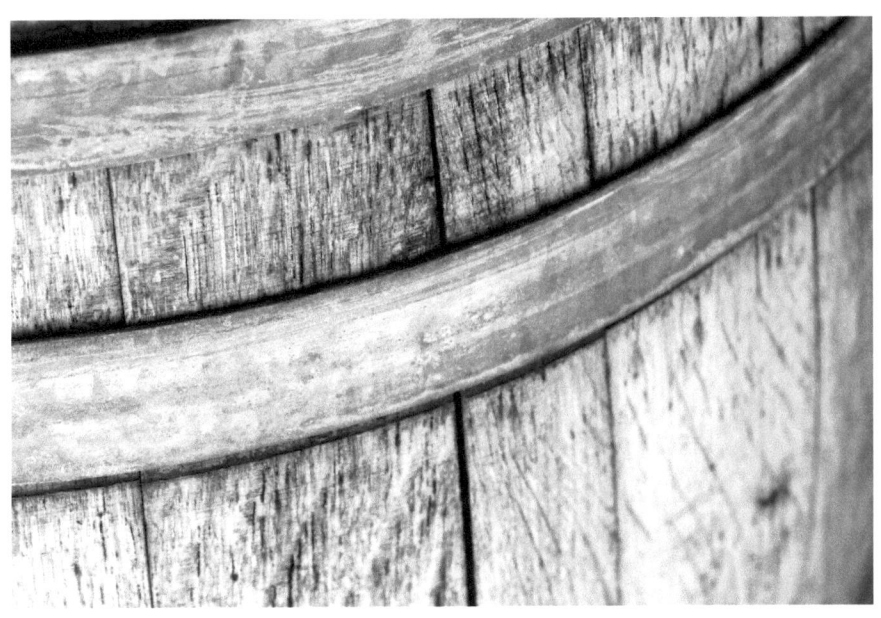

3151

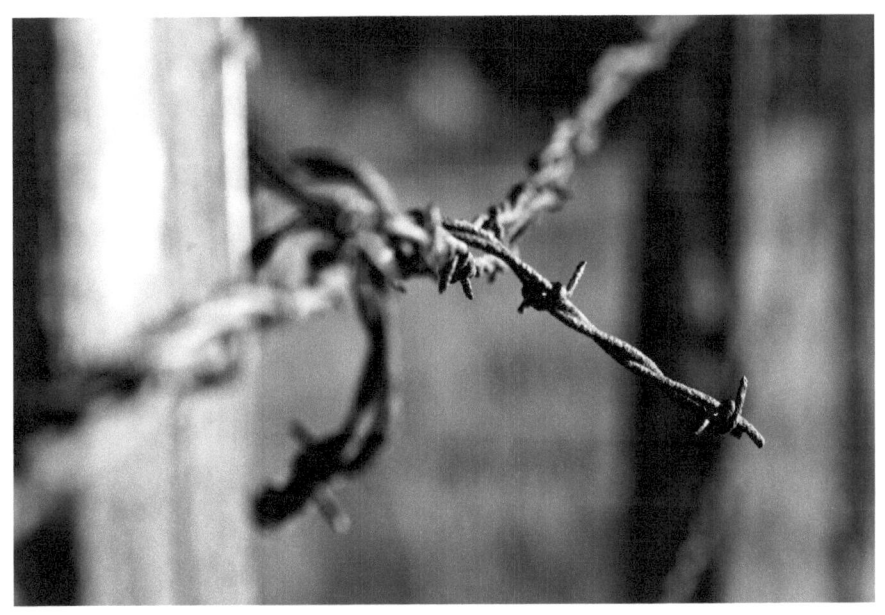

3359

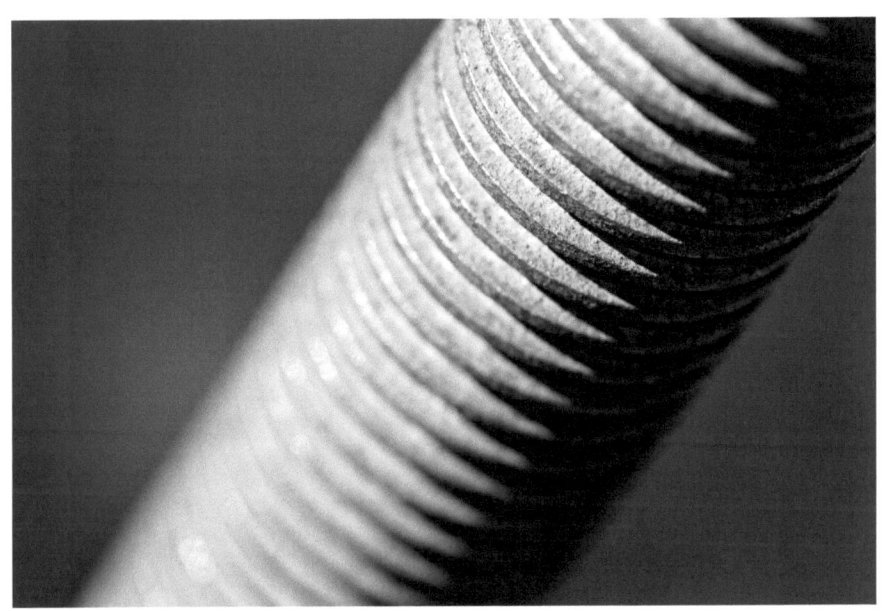

3937

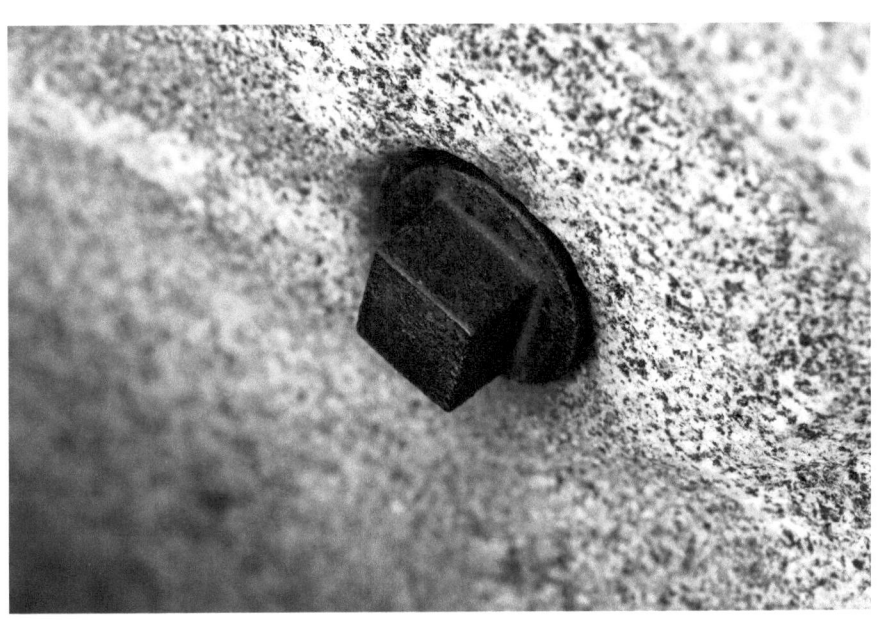

4035

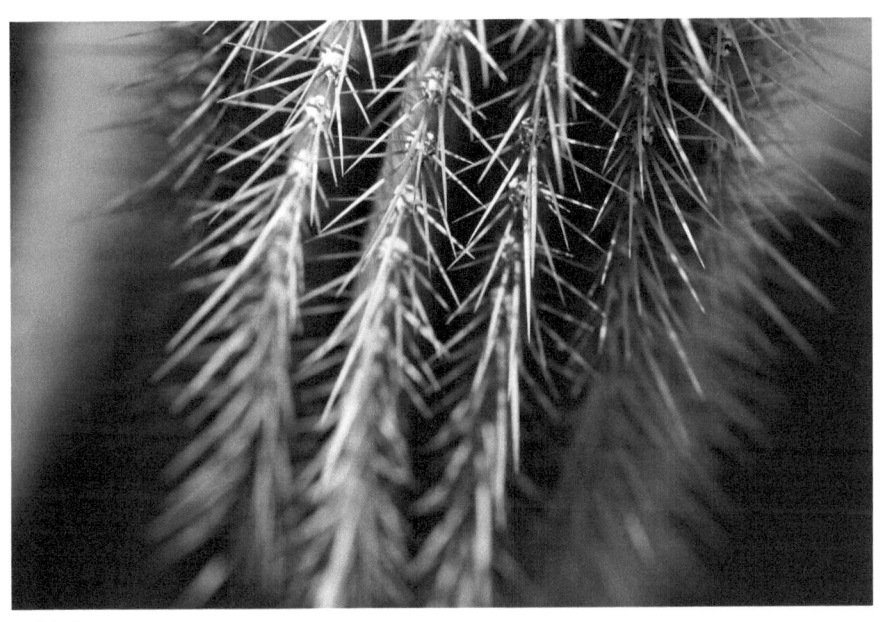

4070

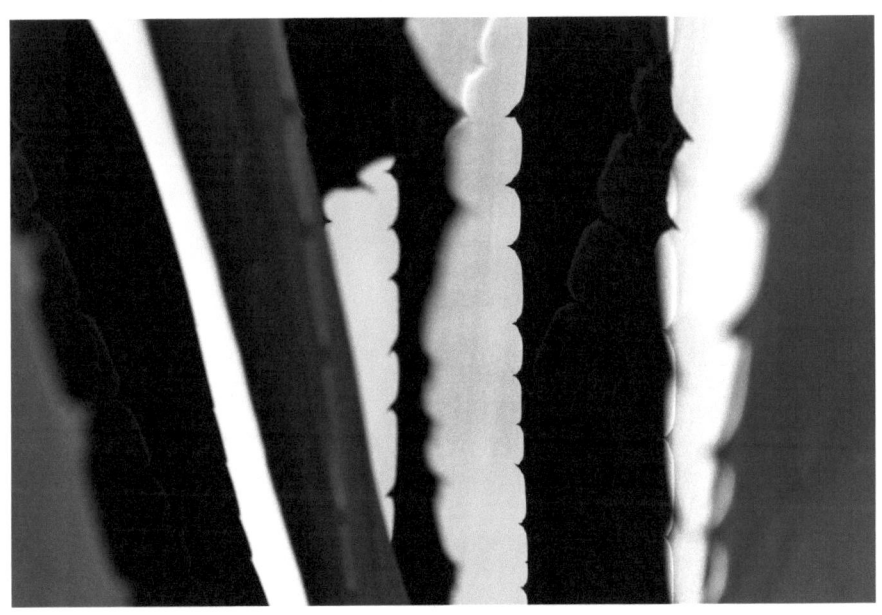

4099

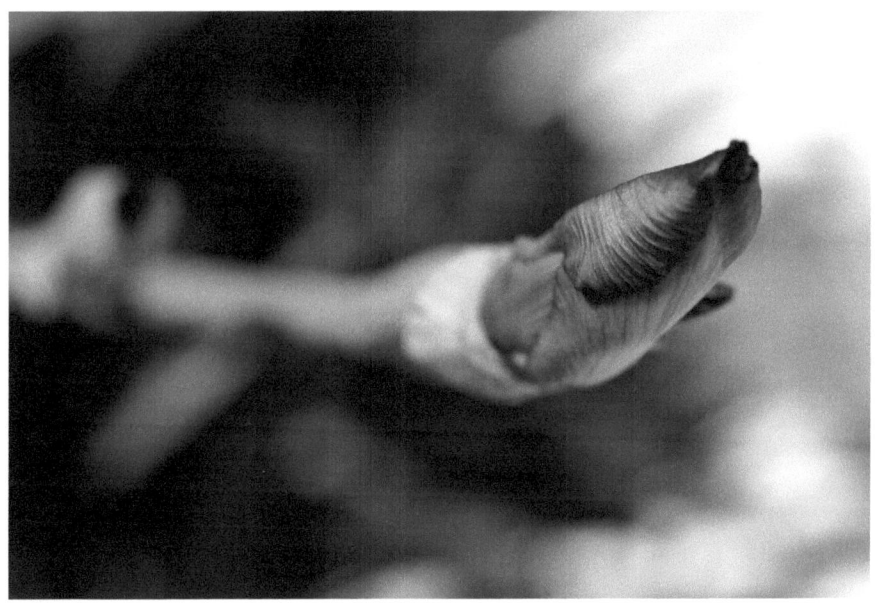

5492

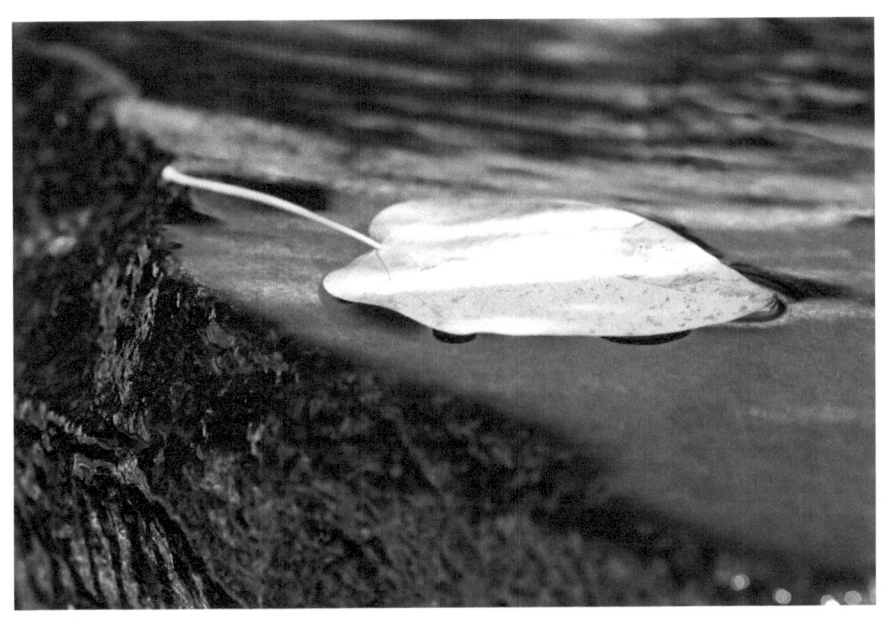

5750

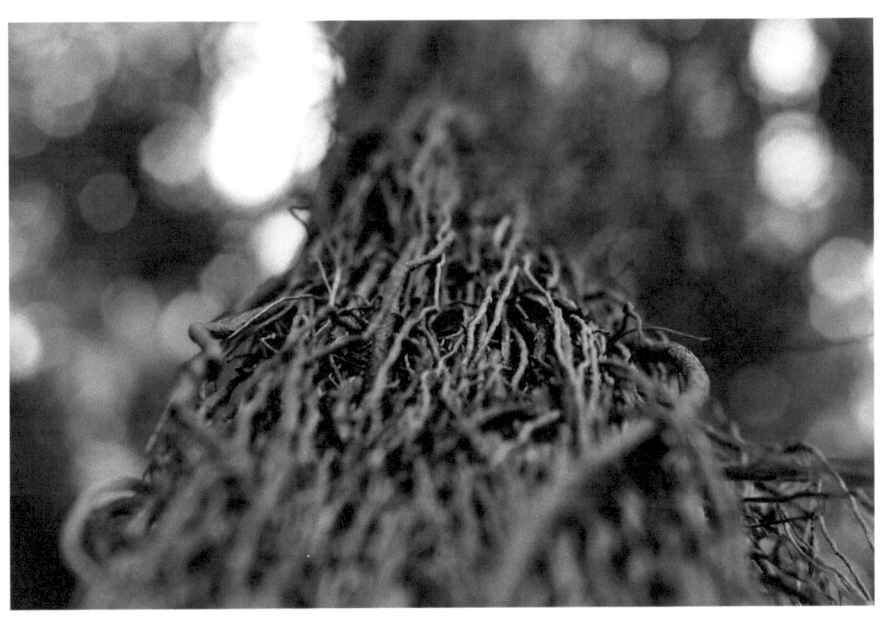

5811

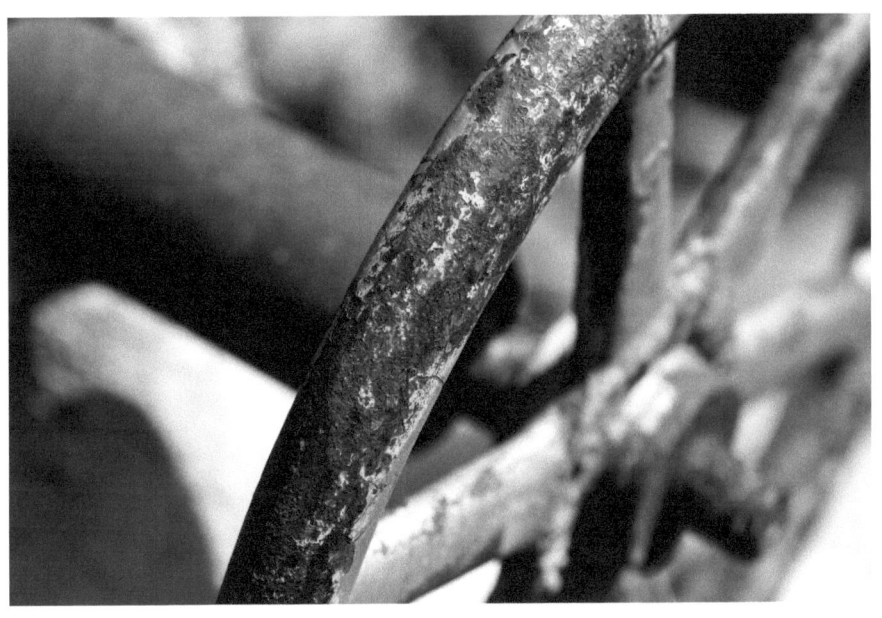

6095

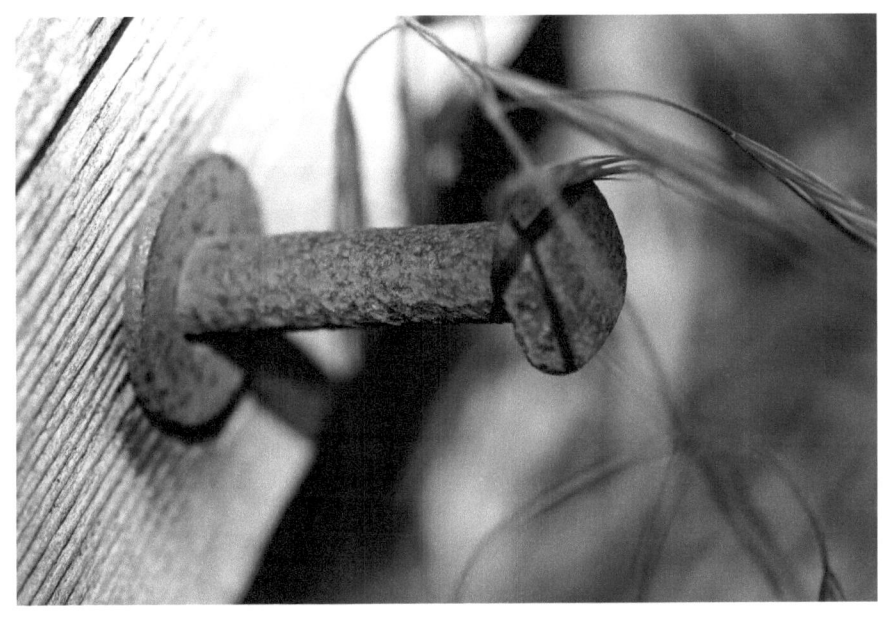

7182

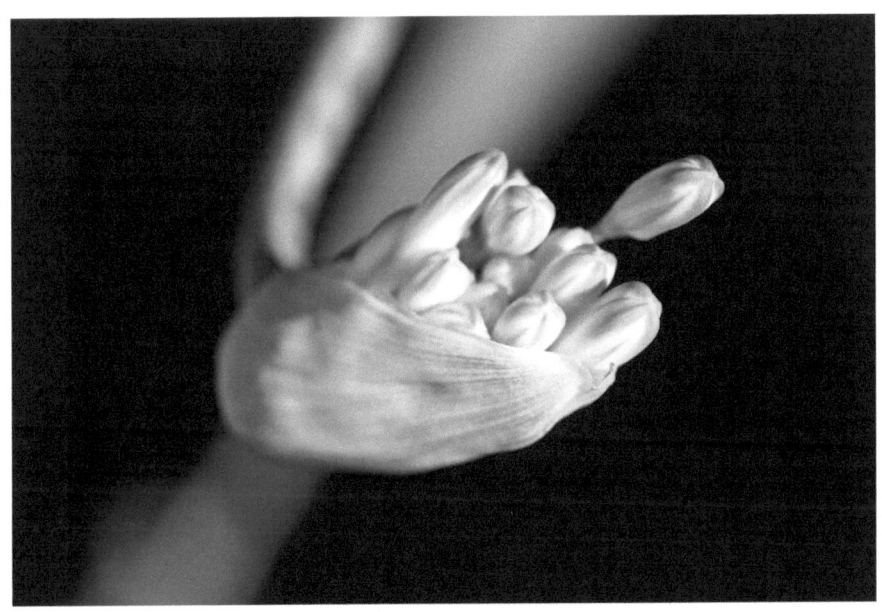

8407

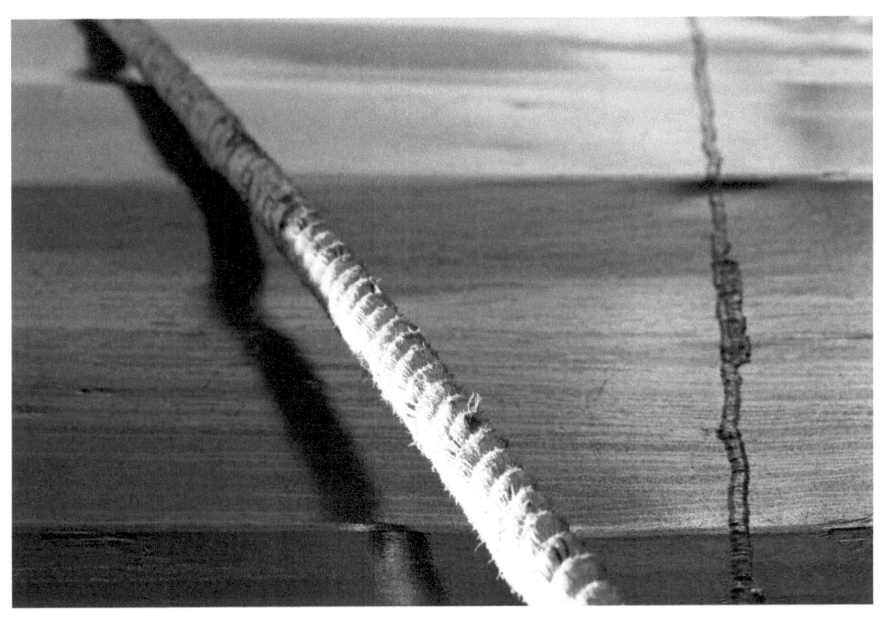

8470

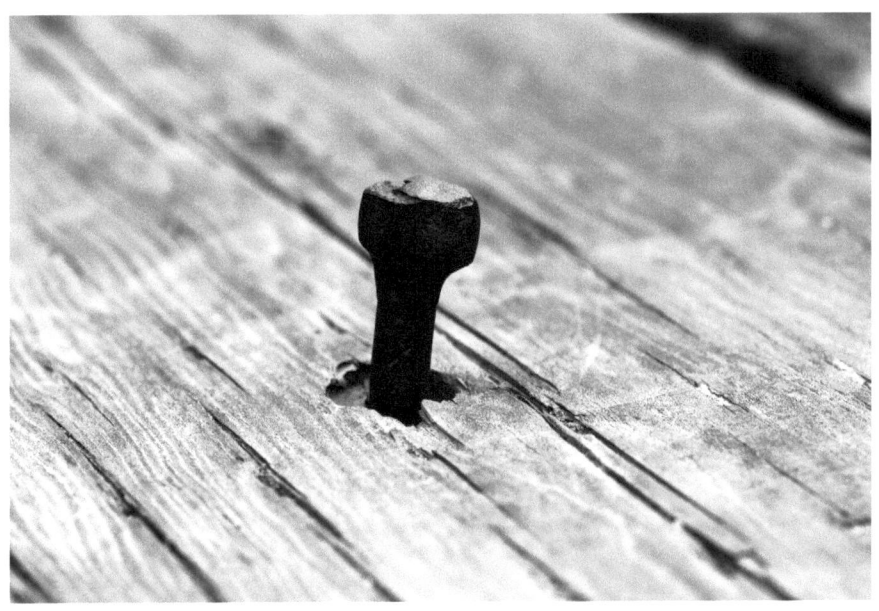

9024

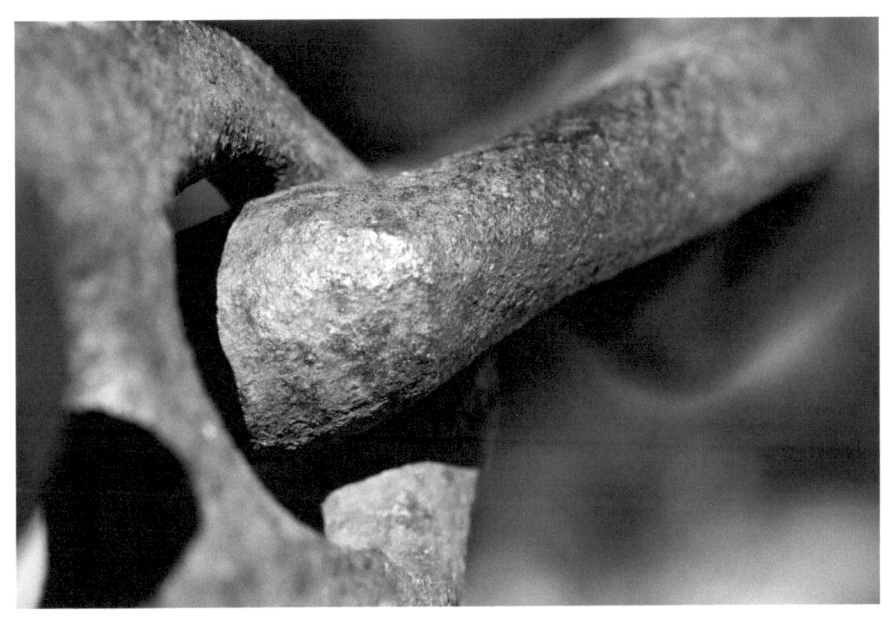

9353

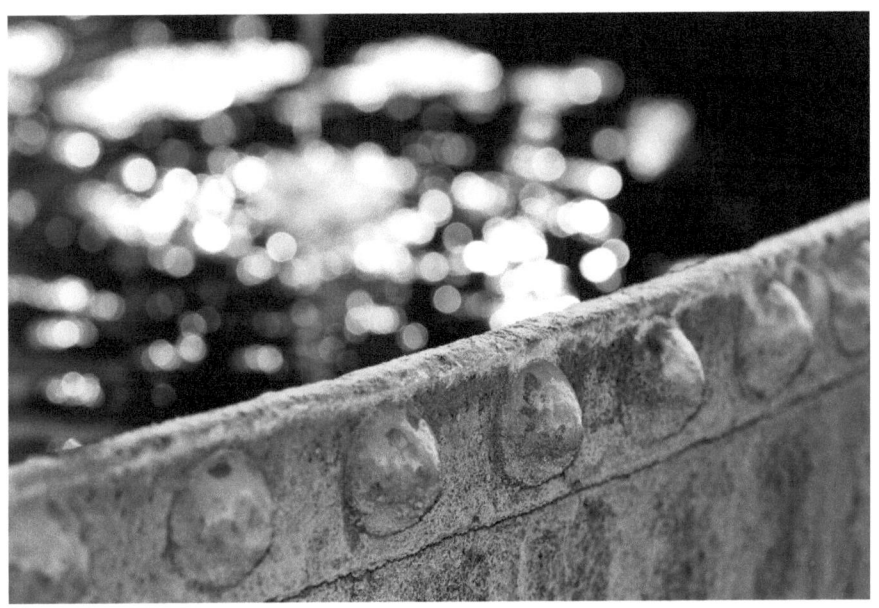

9430

www.ingramcontent.com/pod-product-compliance
Lightning Source LLC
Chambersburg PA
CBHW040919180526
45159CB00002BA/536